To: <u>THE MAN WHO MADE MY</u>
<u>FAIRY Tale COME TRUE</u>

From: <u>CINDERELLA</u>

To Deborah Sue, my love true

Published by
Shake It! Books, LLC
P.O. Box 6565
Thousand Oaks, CA 91359
Toll Free (877) Shake It
www.*shake*that*brain*.com

This book is available at special discounts for bulk purchase for sales promotions,
premiums, fund-raising and educational use. Special books, or book excerpts,
can also be created to fit specific needs. Got a need? We'll try to fill it.

ISBN: 0-9667156-7-5
10 9 8 7 6 5 4 3 2 1

First Edition

Contents

Infatuation

You're just too marvelous, too marvelous for words.
—Johnny Mercer and Ralph Burns

The wish begins at a tender age for that special someone to whom you can say…

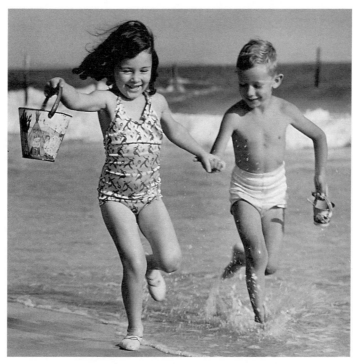

"Baby, you're the tops!"

But time marches on and you drift apart.
(Maybe his parents move away.)
You grow up, start to date, and kiss a lot of frogs.
Then one day—when you least expect it—
it happens again.

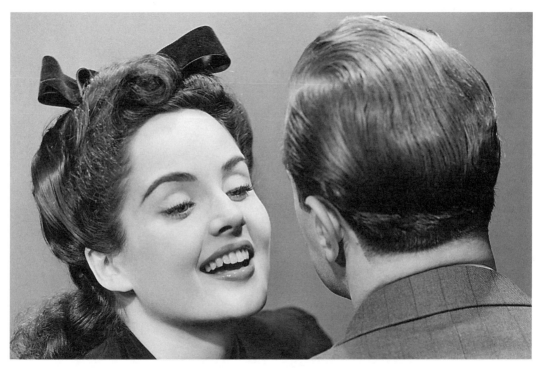

He's funny, charming… and single!

He sings you love songs…

And you swoon like a school girl.

Pretty soon, the news starts to spread.

Meanwhile, friends start to warn him…

"You only just met her. Give it time."

Girlfriends seem wary.
And they won't listen to reason.

"But he's *almost* perfect. And I'll just fix what isn't."

In fact, it's the two of you who won't listen. But why should you? All you can think is…

"We sure make a cute couple!"

Your friends aren't sure
but they hope for the best,
cheering from the sidelines…

"Go kids, go!"

Commitment

Let's do it, let's fall in love.
—Cole Porter

Finally, you just can't help yourself.

"Mom, he's the best!"

And your future together flashes before your eyes.

"Whoa," he says. "Couldn't we slow down a bit?"
Not you. You're ready. So ready for a commitment
you feel like shouting…

"I'm ready!"

But you wait. And wait some more.
Finally, you just can't help yourself. Tears well up.
Big, wet crocodile tears. And it works!

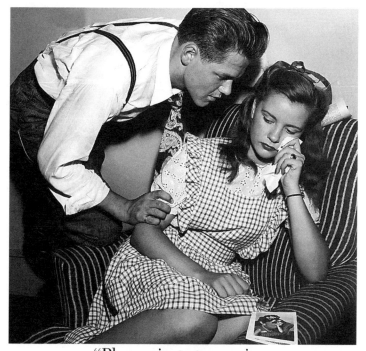

"Please, just stop crying.
I'll do anything you want!"

You're so happy you call your mom. Again.
And mom reminds you, again...

"Remember, dear. No one wants to buy
the cow if he's getting the milk for free."

I resent that.

So the two of you decide to spend your lives together.
Proving to the world, and to yourselves…

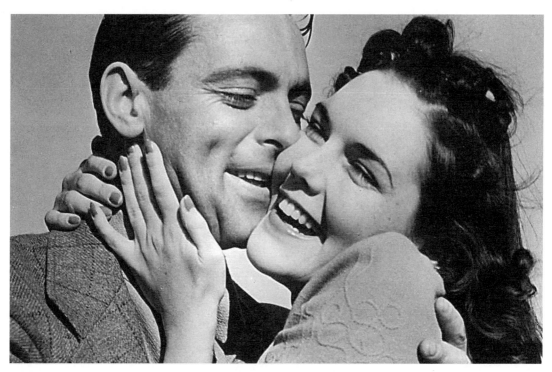

Fairy tales can come true.

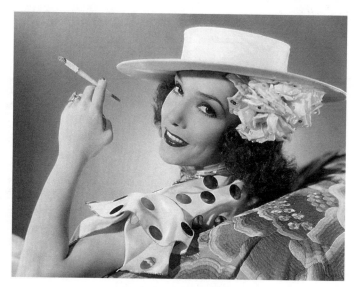

(At least for now.)

Back To Reality

Let's call the whole thing off!
—George and Ira Gershwin

Then little by little…

The romance fades.

And it starts to feel like…

Suddenly, you find yourself thinking...

"What happened? Doesn't he love me any more?"

And he starts to wonder…

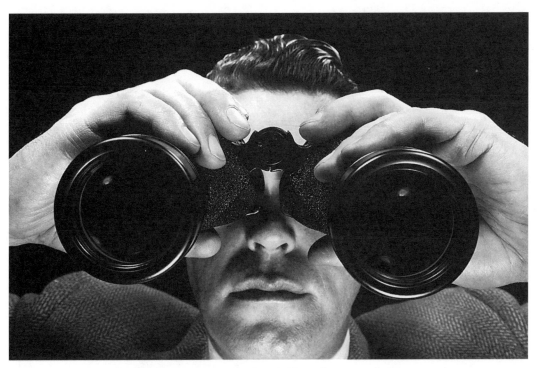

"Where's the girl I fell in love with?"

You remember how he loved the sound of your voice.

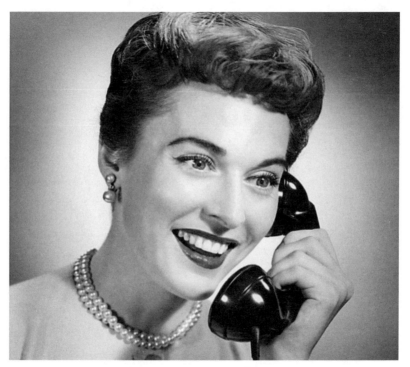

"I was just thinking about you."

Now every time you call, it's like you're *bothering* him.

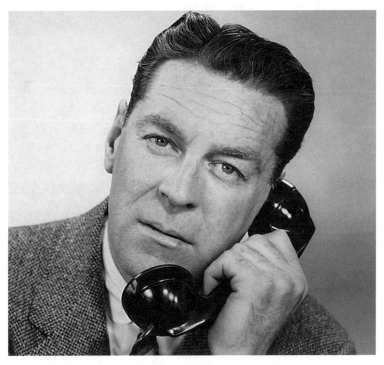

"That's lovely, dear. I just have work to do."

It's like some imposter has stolen your heart
—someone who's only thinking of himself.

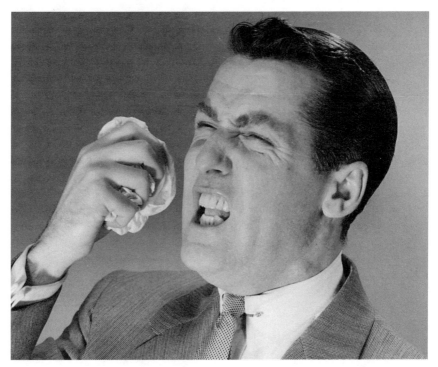

"Don't you understand? I have a cold. The world has to stop!"

There are times, in fact, you feel like saying…

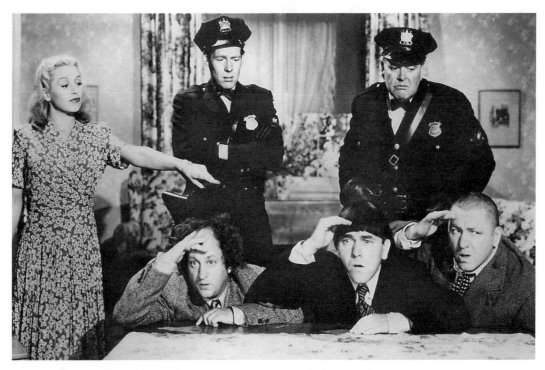

"Officer, this is *not* the man I fell in love with!"

Meanwhile, *he* remembers how you'd laugh at his jokes.

"You are so clever!"

Now it's...

"You don't really think that's funny, do you?"

He even remembers when you thought
he was smart. Now it's…

"Okay, Bob. Which one is *your* brain?"

Meanwhile, he keeps thinking of the good old days —when he used to have a girl on each arm.

(It never happened, of course. But he likes to think it did.)

You even do some daydreaming of your own
—like gazing out the window, thinking…

"I sure love a man in a uniform!"

But you both hang in there. That's your stand
—though even your friends start to wonder…

"Are those two going to make it?"

What happened? Who's to blame?

"Will our love ever be the same?"

In fact, no one's to blame. It's simply
the difference between expectations and reality
—the person you thought you were getting,
compared to…

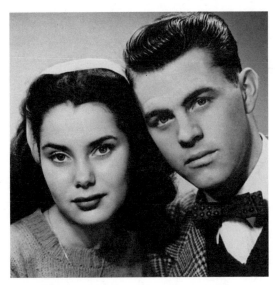

The one you wound up with.

But don't despair. Relief is just a page away.
All it takes is a little…

Bargaining

Don't fence me in.
—Cole Porter

We can work it out.
—Lennon and McCartney

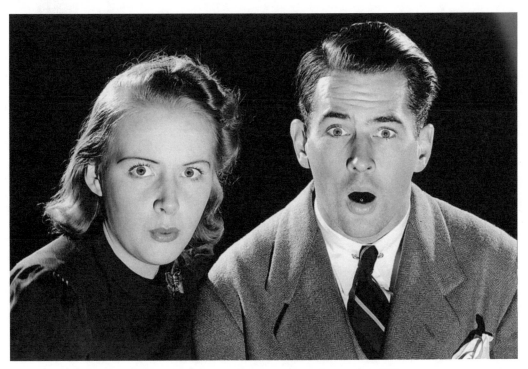

"You mean we have to work at this?!"

Falling in love is the easy part. It's staying that way that takes some work. So instead of saying...

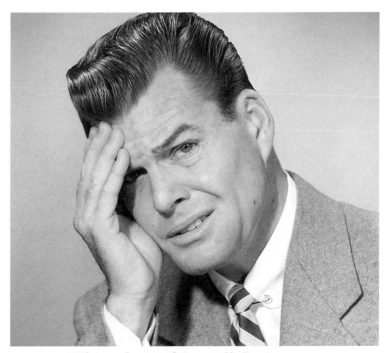

"This relationship stuff. It gives me
a headache just to think about it."

Try to change your attitude a bit.

"Okay, I'm taking notes!"

Tip 1

Make a list.

When you find yourself feeling critical of your beloved, sit down and make a list of "All The Things I Still Love About My Mate." This will remind you of why you first fell in love.

"Hmmm. Something I love about him?"

Pretty soon, you'll find yourself thinking…

"Say, he's not so bad after all!"

And making that list goes for both of you
—to help you both remember the good.

"That's what we do.
And it really works to
remind us of our love."

Tip 2

Start spreading the news.

*At least once a day, <u>compliment</u>
each other.
Because everyone loves
to hear good news.*

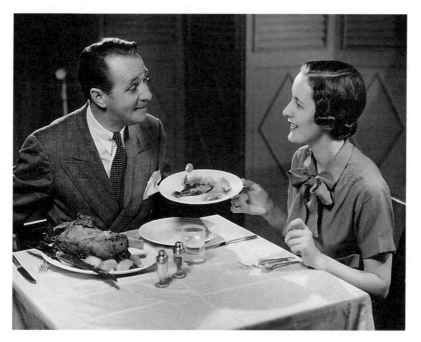

"Thank you, Mary, for taking such good care of me."

"And thank you for scrubbing out the roasting pan!"

Tip 3

Learn what to say.
(And how to listen.)

When it comes to communication,
men and women have different needs.
Men need to hear they've done a good job.

"Honey, I fixed that leak under the sink!"

So remember to compliment him for things he does.
(Even if he doesn't do them that well.)

"Who knew plumbing could be so rewarding?
I'll have to help out more around the house!"

Women need to feel their man is listening.
Men can help by learning the "Mantra for Men"
and practicing it often, saying to themselves,
again and again…

Just listen, don't give advice.
Just listen, don't give advice.
Just listen, don't give advice.

The results can be amazing.

"Wow, he really listened to me!"

Tip 4

Learn to soothe frayed nerves.

When your partner is having trouble coping
— either with the world or with you —
don't shout, don't pout, don't run away.
Just turn to your mate and lovingly say...

"Honey, what do you need from me...
right now?"

So instead of wondering what to say or do…

Should I say X? Do Y? Not do Z? What does that woman want from me?

Just remember those nine magic words:
"Honey, what do you need from me... *right now?*"
No more wondering, no more guess work.

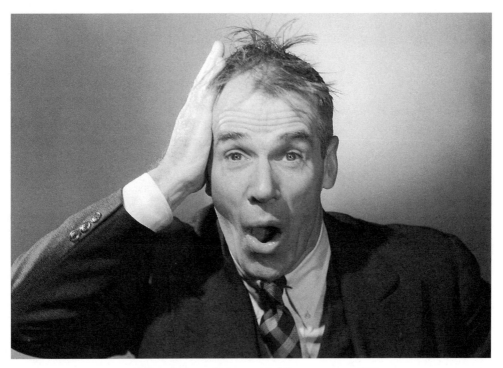

"Who knew life could be so easy!?"

Tip 5

Give a little more.

*Instead of trying to get your way,
try to give a little,
then give a little more.
So instead of...*

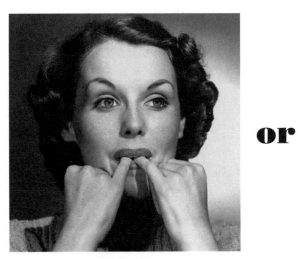

"Listen up, lover boy!"

or

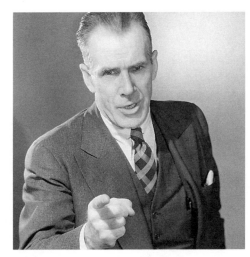

"This is the way it's going to be."

Learn to think more "We" than "Me."
You'll have a lot less...

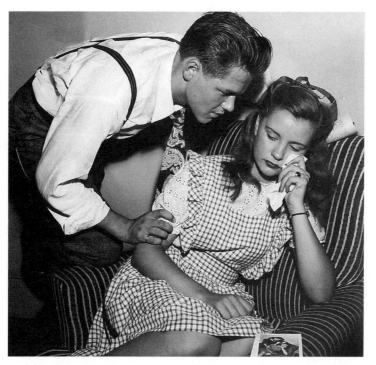

"Gosh, honey. I don't know what I was thinking."

And a lot more…

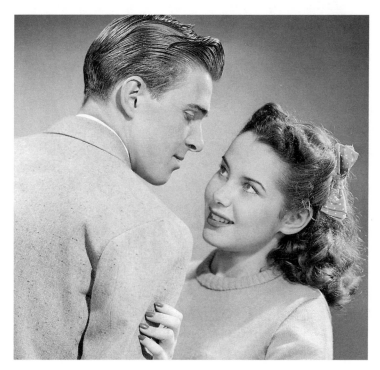

"I know what you're thinking!"

Remember: Follow these tips
and practice them well.
You'll be rewarded with…

Blissful Acceptance

Ac-cent-tchu-ate the positive,
e-lim-in-ate the negative.
—Harold Arlen and Johnny Mercer

Focusing more on "We" than "Me,"
learn to work at this thing called love.

"I feel better already!"

"And I thought going to
the gym was tough."

Overlooking foibles and flaws,
learn to give… and gain a lot more.

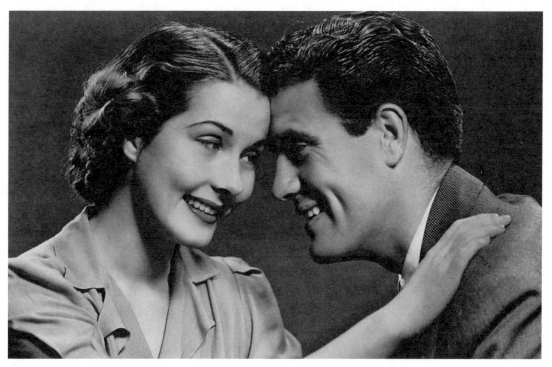

"I sure do love you—ya big lug!"

And it happens! Guaranteed.
You go from thinking…

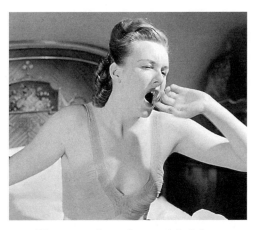 to

Not another day with him. *Hello, Sunshine!*

All you need is some faith…

"Honey, we can do this!"

And some work, to finally see…

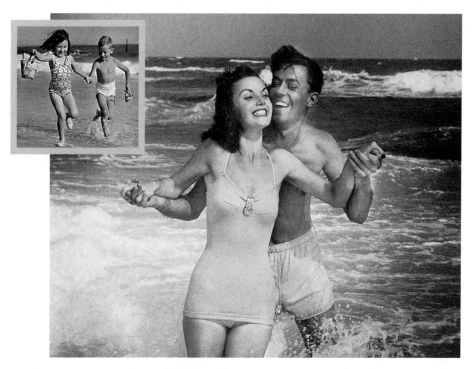

Fairy tales can come true!

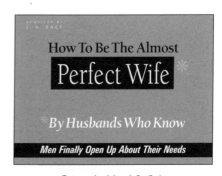

Also available in the "Picture Books for Grown Ups" series...

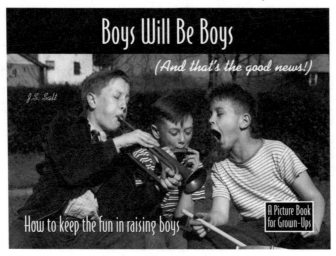

And coming in 2002...

Thank Heaven For Little Girls *(Most of the time!)*